Published by Canon Press
P.O. Box 8729, Moscow, Idaho 83843
800.488.2034 | www.canonpress.com

Stephen Rippon, *Worldview Guide for One Day in the Life of Ivan Denisovich*
Copyright ©2019 by Stephen Rippon.

Cover design by James Engerbretson
Cover illustration by Forrest Dickison
Interior design by Valerie Anne Bost and James Engerbretson

Printed in the United States of America.

A free end-of-book test and answer key are available for download at
www.canonpress.com/ClassicsQuizzes

19 20 21 22 23 24 9 8 7 6 5 4 3

WORLDVIEW GUIDE

ONE DAY IN THE LIFE OF IVAN

DENISOVICH

Stephen Rippon

canonpress
Moscow, Idaho

CONTENTS

INTRODUCTION

In 1961, a Russian schoolteacher submitted a novel based on his experience in the Gulags to Aleksandr Tvardovsky, editor of *Novy Mir*. Tvardovsky "took the manuscript home in the evening, changed into his lounging robe, propped himself up with pillows.... After having read just two or three pages, he got up, put on his office clothes, and resumed his reading. He was, he knew, in the presence of a literary masterpiece, and only dignified attire was fitting for the occasion."[1]

Thus was Aleksandr Solzhenitsyn discovered as a writer. His work would eventually contribute to the Soviet Union's collapse.

1. This account is from Edward E. Ericson, Jr. and Alexis Klimoff, *The Soul and Barbed Wire: An Introduction to Solzhenitsyn* (Wilmington, Delaware: Intercollegiate Studies Institute, 2008), 18-19.

THE WORLD AROUND

To understand the background of the novel, we must look back to the Russian Revolution of 1917. The Revolution found inspiration in the 1848 *Communist Manifesto* of Karl Marx and Friedrich Engels, which begins, "the history of all *hitherto* existing society is the history of class struggles."[2] Led by Vladimir Lenin, the Bolshevik Party persuaded many peasants to join them in a final class struggle to overthrow the Tsarist regime and establish their ideal society: an atheistic, communist state.

Lenin died in 1924, giving way to Joseph Stalin, who became a ruthless dictator. Under Stalin, operations in the Soviet Union became highly centralized. Starting in 1928, Stalin's Five-Year plans collectivized the farms, destroying the traditional way of life. Deprived of their property, many

2. Quoted in Nicholas V. Riasanovsky and Mark D. Steinberg, *A History of Russia*, eighth edition (New York: Oxford University Press, 2011), 481. Riasanovsky and Steinberg add emphasis to hitherto.

peasants moved to the cities, hoping for a better life.[3] Stalin could not tolerate dissent, and eliminated potential opponents in great purges in the 1930s. Stalin established an extensive system of prison camps called *Gulags*. With the purges, starvation caused by his policies, and the Gulag system, Stalin was responsible for the deaths of tens of millions.[4]

Following Stalin's death in 1953, the new Soviet leader, Nikita Khrushchev, was openly critical of Stalin's "cult of personality."[5] During this "thaw," many prisoners were freed from the Gulags, and Khrushchev hoped the publication of *Ivan Denisovich* would discredit Stalin.[6] Providentially, *Ivan Denisovich* came to Khrushchev's attention at a perfect time to fit with Khrushchev's political agenda.

Meanwhile, tensions with the United States were high. In October 1962, just one month before the novel's publication, the Soviet Union and the United States had a confrontation over the Soviets' attempt to deploy missiles to Cuba. The Cuban Missile Crisis brought the United States chillingly close to nuclear war with the Soviet Union, but it was resolved when the Soviets withdrew their missiles.

3. Geoffrey Hosking, *Russian History: A Very Short Introduction* (New York: Oxford University Press, 2012), 97.

4. Estimates range between 20 and 60 million; Solzhenitsyn claimed it was 60 million. See Palash Ghosh, "How Many People did Joseph Stalin Kill?" *International Business Times*, 5 Mar 2013, http://www.ibtimes.com/how-many-people-did-joseph-stalin-kill-1111789 (accessed February 17, 2017).

5. Riasanovsky and Steinberg, 558.

6. Ericson and Klimoff, 18. The authors provide a helpful brief biography of Solzhenitsyn that I have relied on for this guide.

ABOUT THE AUTHOR

Aleksandr Solzhenitsyn was born in Kislovodsk, Russia, on December 11, 1918. His father died before his birth. Though his aunts, who helped raise him, were Orthodox Christians,[7] Solzhenitsyn eventually conformed to his atheistic Soviet education. He studied math and physics at Rostov University and married a fellow student, Natalia Reshetovskaya, in 1940.

During World War II, Solzhenitsyn served as an artillery officer. He was decorated for heroism, but was arrested in 1945 for writing a letter with critical comments about Stalin. Solzhenitsyn was imprisoned for eight years. At first he labored under relatively mild conditions, but in 1950 he was transferred to a "Special Camp" in Ekibastuz, Kazakhstan, the basis for *Ivan Denisovich*.[8] In 1952, while

7. Ericson and Klimoff, 5.

8. For more on this camp, including photographs, see Zhoyamergen Orken, "Fifty Years After 'Denisovich,' Traveling Back To Solzhenitsyn's Gulag," Radio Free Europe/Radio Liberty, November 23, 2012,

still a prisoner, Solzhenitsyn developed cancer. Solzhenitsyn was visited by a doctor, Boris Kornfeld, who recounted his conversion to Christianity. That encounter led to Solzhenitsyn's own return to faith.[9]

Solzhenitsyn was released in February 1953 and exiled to Kok-Terek, Kazakhstan, where he began teaching mathematics and physics and survived another bout with cancer. In 1957, Solzhenitsyn was "rehabilitated" from the charges against him and moved to Ryazan, Russia, where he continued to teach and write.

With the publication of *Ivan Denisovich* in 1962, Solzhenitsyn became internationally famous. While the West absorbed his exposé of the Gulags, Solzhenitsyn faced persecution after Khrushchev was ousted, including monitoring and censorship by the Soviet authorities. A secret network of friends helped Solzhenitsyn by giving him places to write, keeping copies of his manuscripts, and smuggling them out of the country. During these turbulent years, Solzhenitsyn's first marriage ended. In 1973 he married Natalia Svetlova, who was helping him in his work. Svetlova had a son; together they had three more sons.

Late in 1973, *The Gulag Archipelago* was published in Paris. This three-volume, 1800-page work documented the Soviet prison camps with a scope that is as comprehensive

http://www.rferl.org/a/fifty-years-after-denisovich-solzhenitsyn-visit-kazakhstan-former-site-of-gulag-camp-ekibastuz/24779476.html (accessed 17 Feb 2017).
9. Strangely, Kornfeld was murdered later that night. See Ericson and Klimoff, 14.

as *Ivan Denisovich* is compact. As Ericson and Klimoff note, "Two decades later, after the Soviet Union disintegrated, historians would routinely list *Gulag* and *One Day* among the factors contributing to the regime's collapse."[10] The publication of *Gulag* was the "immediate cause" for Solzhenitsyn's arrest in February 1974, his expulsion from the Soviet Union, and his loss of Soviet citizenship.[11] Soviet authorities, including then-head of the KGB Yuri Andropov, had discussed several options including killing Solzhenitsyn as a traitor, sending him back to the Gulag, or exiling him to the West. Instead of making Solzhenitsyn a martyr, they chose to exile him, hoping to gain favor in the eyes of the West for their humane action.[12] Therefore, in February 1974, following his arrest, Solzhenitsyn was sent into exile. Several countries offered invitations for him to settle. During an initial two-year stay in Zurich, Switzerland, Solzhenitsyn considered moving to Canada. Unable to find suitable property in Canada, Solzhenitsyn settled with his family near Cavendish, Vermont.[13] During his twenty years of exile, Solzhenitsyn continued to write and lecture.

Following the collapse of the Soviet Union, Solzhenitsyn returned to Russia in 1994, where he died on August 3, 2008.

10. Ericson and Klimoff, 30.
11. Ibid.
12. Ibid., 32.
13. Ibid., 39.

WHAT OTHER NOTABLES SAID

Russian poet Yevgeny Yevtushenko observed, "Reading this book is an excursion inside the shame of Russia and of humanity. Too bad that Karl Marx and Friedrich Engels can't read this book. They would be horrified, too."[14]

In his biography of Solzhenitsyn, Joseph Pearce wrote, "In its power to undermine the very foundations of the Soviet system, *Ivan Denisovich* would become a literary Ivan the Terrible."[15]

The 1970 Nobel Prize in Literature for Solzhenitsyn cited "the ethical force with which he has pursued the indispensable traditions of Russian literature."[16]

14. Yevgeny Yevtushenko, *Introduction to One Day in the Life of Ivan Denisovich* (1963; New York: Signet, 1998), xvi.

15. Joseph Pearce, *Solzhenitsyn: A Soul in Exile: Revised and Updated Edition* (San Francisco: Ignatius Press, 2011), 154.

16. "Alexandr Solzhenitsyn – Facts," Nobelprize.org, Nobel Media 2014, http://www.nobelprize.org/nobel_prizes/literature/laureates/1970/solzhenitsyn-facts.html (accessed February 18, 2017).

Orthodox theologian Alexander Schmemann noted, "the most joyful news in the 'miracle' of Solzhenitsyn was that the first national writer of the Soviet period of Russian literature was at the same time a Christian writer."[17]

Not all reactions were positive: in a letter to Solzhenitsyn, A.F. Zakharova wrote, "I am absolutely disgusted, like all the officials of MOOP.[18] All are burning with wrath and indignation. It is quite astonishing how much bile there is in this work."[19]

17. Alexander Schmemann, "On Solzhenitsyn," in *Aleksandr Solzhenitsyn: Critical Essays and Documentary Materials*, trans. Serge Schmemann, ed. John B. Dunlop, Richard Haught, and Alexis Klimoff (New York: Collier, 1975), 39.

18. Ministervo Okhrany Obshchestvennogo Poriadka, the Ministry for the Preservation of Public Order.

19. Quoted in Leopold Labedz, ed., *Solzhenitsyn: A Documentary Record* (New York: Harper & Row, 1971), 35.

SETTING, CHARACTERS, AND PLOT SUMMARY

- Time: A single day in January 1951.
- Location: A Soviet prison camp, known as a Gulag.
- Shukhov (Ivan Denisovich): A 40-year-old prisoner (or *zek*) in the Gulag. The narrator refers to him by his last name, Shukhov, while others call him by his first name (Ivan) and patronymic (Denisovich)[20] or his prisoner number (*Shcha-854*).[21] We experience prison life from Shukhov's perspective.
- Alyoshka the Baptist: Shukhov's bunkmate. He embodies the Christian faith in his good work

20. Russian names are interesting: there is a first name (the Christian name Ivan—the same name as *John*) and a second name (a patronymic, identifying the father's name: Denisovich thus means "son of Denis"), followed by the family name (Shukhov).

21. *Shcha* is a letter in the Cyrillic alphabet, which Russian uses. Other translations call him "S-854."

ethic, his concern for others, his meditation on the Scriptures, his joy despite suffering, and his willingness to engage in spiritual discussions.

- Tyurin (Andrei Prokofyevich): The foreman of Shukhov's gang. Imprisoned as the son of a *kulak*,[22] Tyurin has been a prisoner for 19 years. He is a good leader.
- Pavlo: The deputy foreman of Gang 104. Pavlo, a Ukrainian, is characterized by politeness and consideration for others.
- Captain Buynovsky: A former naval captain, newly imprisoned. Having been treated with respect in the military, he has trouble adjusting to prison life.
- Tsezar Markovich: A filmmaker who has a privileged life as a prisoner. He receives packages of food from home and works in a warm office. He engages in conversations about the cinema whenever he can.
- Fetyukov: A lowly prisoner who had a good position in the outside world, but is now reduced to begging in the camp.

22. *Kulaks* were well-to-do peasants whom Stalin targeted to be eliminated (88 in footnote). This Worldview Guide refers to the text of Aleksandr Solzhenitsyn's *One Day in the Life of Ivan Denisovich*, trans. H.T. Willetts (New York: Farrar, Straus, and Giroux, 2014). Willetts' translation, originally published in 1991 and slightly revised since then, is the only English translation authorized by Solzhenitsyn.

- Panteleyev: A prisoner with a reputation for informing on other prisoners in exchange for not having to work outside in the cold—even as other "squealers" have been turning up with their throats cut.

- Gopchik: A 16-year-old prisoner. Shukhov has a special attachment to Gopchik because Shukhov's own son died as a little boy, and Gopchik shows cleverness that resembles Shukhov's.

- Kildigs (Jan or "Vanya"): A Latvian that Shukhov refers to by his diminutive, Vanya. Like Shukhov, Kildigs is a skilled worker whose remarks are darkly humorous.

- Klevshin ("Senka"): Shukhov's partner during the day's work of bricklaying. He is nearly deaf. He displays loyalty to Shukhov.

The day of the novel is in the eighth year of Ivan Denisovich Shukhov's ten-year sentence. It is bitterly cold outside, with temperatures below -20° Celsius (-4° Fahrenheit). Shukhov wakes at reveille and feels ill. Contrary to his habit, Shukhov lingers on his bunk. For failing to get up, Shukhov is to be punished with three days "in the hole" (7), an especially dreaded place involving solitary confinement, very little food, and cold, damp conditions. However, the guard mercifully redirects Shukhov to wash a floor in the administrative building.

After finishing that job, Shukhov eats breakfast at the mess hall, goes to the sick bay in an unsuccessful attempt to be let off work, and assembles with the other prisoners to march out to the worksite. Shukhov's work gang is assigned to build up the cinder block walls of a power station. In the hours before dinner (the mid-day meal), the men prepare the work site and try to warm it up inside. At dinner, Shukhov finagles an extra portion of gruel for himself.

In the remaining hours of the work day, Shukhov builds a wall on the second floor of the building, while the others make mortar and bring the mortar and bricks up. Shukhov finds great satisfaction in building a good wall. As the prisoners line up to be inspected upon reentry to camp, Shukhov remembers that he had picked up a piece of metal, hoping to make a knife out of it; if caught, this could result in ten days in the hole. Shukhov prays to God that his contraband will not be discovered, and he barely escapes detection.

Back inside camp, Shukhov stands in line for Tzesar, who is expecting a package. Shukhov is rewarded with Tsezar's supper ration, as Tzesar enjoys a package of rich food sent from home. Shukhov then buys tobacco from a Latvian before returning to his own bunk.

In the moments before lights out, Shukhov's bunkmate, Alyoshka the Baptist, engages Shukhov in a discussion about prayer and the Christian life. Shukhov expresses skepticism. Shukhov then reviews his day: despite a bad start, many things went relatively well, so that this day was "almost a happy one" (181).

WORLDVIEW ANALYSIS

What makes this novel so remarkable? Historically, the novel is important as an exposé of the injustice and suffering in the Soviet Gulag system. Solzhenitsyn's work, starting with *Ivan Denisovich*, is credited with helping to bring about the collapse of the Soviet Union. As Solzhenitsyn scholars Edward E. Ericson, Jr. and Daniel J. Mahoney write in their introduction to *The Solzhenitsyn Reader*, "Today most informed observers appreciate the central role that Solzhenitsyn placed in the defeat of communism. More than any other figure in the twentieth century, he exposed the ideological 'lie' at the heart of Communist totalitarianism."[23]

But what accounts for the novel's historical impact, and what makes it worth reading today long after the fall of

23. Edward E. Ericson and Daniel J. Mahoney, Introduction to *The Solzhenitsyn Reader: New and Essential Writings 1947-2005*, ed. Edward E. Ericson, Jr., and Daniel J. Mahoney (Wilmington, Delaware: Intercollegiate Studies Institute, 2006), xxxix.

the Soviet Union? *Ivan Denisovich* succeeds on many levels. First, Solzhenitsyn tells a fascinating story of survival. Second, the novel is a great work of art in keeping with the classical ideals of truth, goodness, and beauty. Finally, *Ivan Denisovich* is a deeply Christian work that reflects a biblical theology of creation, fall, and redemption.

On a basic level, the story succeeds as a tale of human survival. Readers familiar with *Robinson Crusoe* may remember the pleasure of learning how Crusoe can do so much on his island with so little left from the shipwreck. A similar principle enlivens this novel. How does Shukhov manage to survive amidst harsh conditions?

Shukhov has learned much about survival over his eight years in prison. For example, as Shukhov washes a floor underfoot of prison administrators who are idly talking, he reflects, "There are two ends to a stick, and there's more than one way of working. If it's for human beings—make sure and do it properly. If it's for the big man—just make it look good. Any other way, we'd all have turned our toes up long ago, that's for sure" (14). At breakfast, Shukhov muses on another rule of survival: "food swallowed in a hurry is food wasted, you feel no fuller and it does nothing for you" (26).

One key to survival is companionship. There is a tension in the novel between the need to look out for one's own interests—"It's dog eat dog here" (75)—and the way the prisoners take care of each other. The work gang is "like a big family. That's what a work gang is—a family" (88). The

foreman and deputy, Tyurin and Pavlo respectively, act as parents who look out for the workers in their gang. Also, Alyoshka the Baptist consistently looks out for others instead of himself, just as Philippians 2:1-4 says we should. Alyoshka always lends a hand without complaining, quietly helping the gang to survive. The inclusion of Alyoshka in the novel suggests that there is more to survival than mere self-interest.

Not only does the novel give us an edifying account of survival, but it is also a great work of art, transcending the Stalin-discrediting agenda with which Khrushchev initially approved its publication. To appreciate how *Ivan Denisovich* succeeds as a work of art, we may consider the principles Solzhenitsyn himself explained in his "Nobel Lecture," written after the author was awarded the 1970 Nobel Prize in Literature.[24]

Solzhenitsyn begins his "Nobel Lecture" by contrasting two views of the artist. One is the modern artist, who "imagines himself the creator of an autonomous spiritual world," while the other artist "recognizes above himself a higher power and joyfully works as a humble apprentice under God's heaven."[25] Of the second type of artist, Solzhenitsyn says, "It is merely given to the artist to

24. Ericson and Mahoney describe the lecture as "a near-perfect encapsulation of Solzhenitsyn's artistic and moral-political concerns and their essential harmony." See their Introduction, xxxi. This lecture is also available online at http://www.nobelprize.org/nobel_prizes/literature/laureates/1970/solzhenitsyn-lecture.html.

25. Solzhenitsyn, "Nobel Lecture," 513.

sense more keenly than others the harmony of the world, the beauty and ugliness of man's role in it—and to vividly communicate this to mankind." [26]

Solzhenitsyn explains that he attempts to speak for many other artists who did not survive the Gulags. Upon his release, Solzhenitsyn experienced the alienation of finding his society incapable of understanding his experiences. That problem of misunderstanding drives his "Nobel Lecture" forward. Solzhenitsyn observes, "Onrushing waves of events bear down upon us: Half the world learns in one minute of what is splashed ashore. But lacking are the scales or yardsticks to measure these events and to evaluate them according to the laws of the parts of the world unfamiliar to us."[27] For example, "A flood with two hundred thousand victims seems less important than a minor incident in our home town."[28] We may sense this problem even more keenly in the 21st century: we experience a constant barrage of Facebook updates, Twitter feeds, and news tickers juxtaposing troubling news of wars, death, and natural disasters with trivial gossip about sports, friends, and Hollywood. So Solzhenitsyn poses the question, "who will reconcile these scales of values and how?" Solzhenitsyn then answers his own question: "But fortunately there does exist a means to this end in the world! It is art. It is literature." Literature

26. Solzhenitsyn, "Nobel Lecture," 513.

27. Ibid., 517.

28. Ibid., 518.

"recreates—lifelike—the experience of other men, so that we can assimilate it as our own."[29]

But how can an author recreate this experience effectively? An attempt to tell Shukhov's story over all 3,653 days, or to add his story to the stories of millions of others who lived in the Gulags, would put the narrative beyond comprehension.[30] Statistics on the scale of thousands and millions do not connect with readers; as Stalin reportedly said, "One death is a tragedy; one million is a statistic."[31] In order not to become numb to evil, we need concrete details arranged on a human scale, one that is comprehensible to us as finite creatures. Solzhenitsyn's artistic shaping of one small subject—one day in one prisoner's life—makes *Ivan Denisovich* effective in telling the truth about a much larger phenomenon.

Another challenge for artists like Solzhenitsyn is to communicate their vision without coming across as "preachy," which would turn many readers off. To understand how Solzhenitsyn succeeds in this in *Ivan Denisovich*, we must also consider the role of beauty. Solzhenitsyn suggests that beauty has a unique advantage in conveying truth and goodness in a non-preachy way. Earlier in the "Nobel Lecture," he had observed this: "If the tops of these

29. Solzhenitsyn, "Nobel Lecture," 519.

30. Solzhenitsyn would later undertake a more comprehensive work documenting the Gulag system in a three-volume work, *The Gulag Archipelago: An Experiment in Literary Investigation*.

31. Quoted in Ghosh, "How Many People did Joseph Stalin Kill?"

three trees [truth, goodness, and beauty] do converge, as thinkers used to claim, and if the all too obvious and the overly straight sprouts of Truth and Goodness have been crushed, cut down, or not permitted to grow, then perhaps the whimsical, unpredictable, and ever surprising shoots of Beauty will force their way through, and soar up to *that very spot*, thereby fulfilling the task of all three."[32] Thus, in the context of a regime founded on lies, such as he was then suffering under in the Soviet Union, Solzhenitsyn concludes his "Nobel Lecture": "Lies can prevail against much in this world, but never against art."[33]

In the case of *Ivan Denisovich*, this artistic beauty emerges through the Christian imagery in the novel, which points to the beauty of creation and redemption. *Ivan Denisovich* masterfully portrays "the triune intuition of creation, fall, and redemption," as Alexander Schmemann put it. In other words, the novel reflects a biblical theology.

Biblical theology begins with creation. As Schmemann points out, "The Christian vision is rooted in a perception and acceptance of the original goodness of the world and life.... No matter how real the ugliness, suffering and evil in the world, no matter how fallen it is—and Christianity firmly maintains that it 'lies in evil'—fundamentally, originally the world is light and not dark, meaningful and

32. Solzhenitsyn, "Nobel Lecture," 515.
33. Ibid., 526.

not meaningless, good and not bad."[34] While the current circumstances of the fallen world are obvious in the novel, one theme that shines through is the "intuition of *creation*."[35]

In *Ivan Denisovich*, we see the goodness of creation despite the bleak circumstances of prison life. For example, we see Shukhov's great satisfaction in doing work, as Adam was created to do. In Shukhov's reckoning, the worst part about being put "in the hole" is not getting to work (8). One thing that makes the day of the novel "almost a happy one" is that he gets to work at building a wall, which is "a job to take pride in" (66). Shukhov gets so engaged in his work that he forgets that he had woken up feeling ill (128). Gary Kern, a specialist in Russian studies, argues that Shukhov's work ethic reveals his motivation is not merely survival, but something higher: "Ivan does not work for immediate rewards. To demonstrate this point, Solzhenitsyn constructs a situation free from any utilitarian benefit, one which epitomizes Ivan's spiritual contradiction to the pressures of his environment."[36] Kern goes on to point out how Shukhov remained at the work site so he could finish the job and even admire his own work, at the risk of getting in trouble. We read, "If the guards had

34. Schmemann, 39.

35. Ibid., 40.

36. Gary Kern, "Ivan the Worker," *Modern Fiction Studies* 23 (1977): 5-30. Kern's article provides a superb close reading of the novel overall, enhanced by Kern's attention to the Russian text.

set their dogs on him, it wouldn't have stopped Shukhov. He moved quickly back from the wall to take a good look. All right. Then quickly up to the wall to look over the top from left to right. Outside straight as could be. Hands weren't past it yet. Eye as good as any spirit level" (113). Shukhov shows that he is created in the image of God; just as God said "it is good" after each day of creation, Shukhov wants to say the same about his work.

If we have a biblical understanding of the goodness of creation, we also will have a keener sense of the tragedy of the Fall. On top of the obvious injustices within the Gulag and the Soviet system overall, the Fall of man is also evident in the novel's depiction of displacement and exile. While not many of us have faced physical imprisonment or political exile as Solzhenitsyn did, we can still identify with these conditions: all mankind, after all, has been removed from the Garden of Eden as a result of the sin of Adam and Eve, our first parents.

The theme of displacement rings true for us experientially as well. At some point, we will be displaced—if not physically, then perhaps emotionally, upon the death of a loved one or some other change. While Shukhov is physically displaced, he also is troubled emotionally by the changes in his hometown he learns of through letters from his wife (42).

As Christians, we sense our own displacement all the more poignantly because we have already tasted of redemption. In the early Church, the apostle Peter, whose

letter is quoted by Alyoshka the Baptist in the novel (27), addresses his fellow believers as "exiles" (1 Pet. 2:11). The apostle Paul, writing from prison, reminds us that "our citizenship is in heaven" (Phil. 3:20). We thus continue to experience alienation, living as a redeemed people in a fallen world.

Just as reading of Shukhov's imprisonment puts our own displacements in perspective, reading of Alyoshka the Baptist's determination to rejoice gives us a model of how to live as we await the day when Heaven and earth will be one. Alyoshka prays and meditates on God's Word, and he is clearly sustained in prison: "Life in the camp was like water off a duck's back to them [the Baptists]" (45). He also encourages Shukhov to pray: in the evening Alyoshka overhears Shukhov thank God, and Alyoshka says, "There you are, Ivan Denisovich, your soul is asking to be allowed to pray to God. Why not let it have its way, eh?" (145).

Another redemptive element that may not be immediately apparent is the sacramental imagery—especially sacraments particular to the Orthodox Church.[37] Shukhov eats with a spoon that he made out of wire at a previous camp: "That spoon was precious, it had traveled all over the north with him" (16). In the Orthodox Church, the sacrament of the Lord's Supper is administered with a spoon.

37. Here I am indebted to my colleague at Tall Oaks Classical School, Dr. Stephen Turley, who pointed out to me that certain aspects of the novel reflect sacraments in the Orthodox Church.

Christianity reveals the connection between the material and the spiritual. The meager prison-camp food—so much a focus of Shukhov's thoughts—is savored, so that every meal resembles a sacrament. At breakfast, "He started eating slowly, savoring it.... If the roof burst into flames, he still wouldn't hurry. Apart from sleep, an old lag can call his life his own only for ten minutes at breakfast time, five at lunchtime, and five more at suppertime" (17). We know from Scripture that meals are about much more than mere physical survival. For the people of God, in both the Old Testament and New, meals were significant. Passover, for example, reminded Israel of God's deliverance of them and pointed forward to the ultimate Passover Lamb, Jesus Christ. Christ Himself instituted the Lord's Supper, a meal of bread and wine, to be real spiritual nourishment for us. With a sacramental imagination, we may praise God's goodness in even the most ordinary things. Therefore, we should not underestimate the significance of food in *Ivan Denisovich*.

Ivan Denisovich has much to offer us. In allowing this work to be published, Khrushchev may have thought he was going to make Stalin look bad, but he unwittingly promoted a moral vision that far transcended his propagandistic purposes. Whether we read it for its account of human survival against brutal conditions, for its aesthetic brilliance, or for its reflection of the Christian life, we see that this is a work that rewards reading not merely once, but again and again—a sure sign of a classic.

QUOTABLES

1. The hammer banged reveille on the rail outside camp HQ at five o'clock as always. Time to get up. The ragged noise was muffled by ice two fingers thick on the windows and soon died away. Too cold for the warder to go on hammering. (3)

2. Can a man who's warm understand one who's freezing? (24)

3. There is no worse moment than when you turn out for work parade in the morning. In the dark, in the freezing cold, with a hungry belly, and the whole day ahead of you. You lose the power of speech. You haven't the slightest desire to talk to each other. (28)

4. A convict's thoughts are no freer than he is: they come back to the same place, worry over the same thing continually. Will they poke around in my mattress and find

my bread ration? Can I get off work if I report sick tonight? (40)

5. It's dog eat dog here. (75)

6. The belly is an ungrateful wretch, it never remembers past favors, it always wants more tomorrow. (153-54)

7. "What good is freedom to you? If you're free, your faith will soon be choked by thorns! Be glad you're in prison. Here you have time to think about your soul." ~Alyoshka the Baptist (177)

8. The end of an unclouded day. Almost a happy one. // Just one of the 3,653 days of his sentence, from bell to bell. // The extra three were for leap years. (181-82)

21 SIGNIFICANT
QUESTIONS AND ANSWERS

1. Since the novel was originally written in Russian, what might be lost in translation?

 While many nuances get lost in translation, even for Russian readers the language was challenging in the same way you might stumble over the colloquial language in *Huckleberry Finn*.[38] The language of the novel represents how, as a peasant without much formal education, Shukhov would speak. This type of narration is called the "free indirect style," where the voice of the character and the narrator are fused. It overlaps with a traditional type of Russian storytelling called *skaz*.[39] The profanity also reflects how pris-

38. Alexis Klimoff, "The Sober Eye: Ivan Denisovich and the Peasant Perspective," in *One Day in the Life of Ivan Denisovich: A Critical Companion*, ed. Alexis Klimoff (Northwestern University Press, 1997), 24.

39. For more explanation, see Robert Porter, *Solzhenitsyn's* One Day in the Life of Ivan Denisovich, Critical Studies in Russian Literature

oners spoke; however, readers should note contrasts among the prisoners' speech. Some prisoners, like the Ukrainians and Alyoshka the Baptist, stand out for their gracious speech. Speech reveals character in the novel, just as Jesus taught: "For out of the abundance of the heart the mouth speaks" (Matt. 12:34).

2. What examples of injustice do we see in Ivan Denisovich?

There are many examples of injustice. Shukhov was arrested on false charges; he had to admit that he was a spy or else be killed (70). Alyoshka and the other Baptists were imprisoned "just for being Baptists" and given a 25-year sentence (45). Also, the prisoners were often forced to work even on Sundays (53).

3. Shukhov looks favorably on some fellow prisoners. Describe at least three other prisoners he respects.

Shukhov respects his gang boss, Tyurin, and the assistant gang boss, Pavlo. Tyurin stands up for his gang: "a chest of steel, Tyurin had" (46). Pavlo shows mercy and kindness to Shukhov, and is "more important to Shukhov than the camp commandant" (25). Shukhov admires young Gopchik for his ability to survive (149). Finally, he admires Alyoshka the Baptist for his helpfulness: "They've got the right idea, that lot," he says, characterizing the Baptists as a whole (109).

(Bristol Classical Press, 1997), 39.

4. Shukhov views other prisoners unfavorably. Describe two other prisoners he regards negatively.

 > Shukhov resents Panteleyev for being a squealer (29). He also does not respect Fetyukov because he is a beggar (31).

5. What are some things that Shukhov has learned about how to survive in the Gulag? Identify at least three lessons.

 > There are many observations about survival in prison. For one thing, Shukhov has learned to be vigilant: "You had to be wide awake all the time. Make sure a warder never saw you on your own, only as one of a crowd" (19). Prisoners need to know how to hide things, too; for example, Alyoshka hides his Bible in a crack in the wall, so it is not confiscated (27). Prisoners also need to rest and get warm whenever they can: "While the bosses were getting organized—snuggle up in the warm, sit there as long as you can, you'll have a chance to break your back later, no need to hurry" (48).

6. Where do we see humanity transcending mere survival and showing what it means to be created in the image of God?

 > Shukhov finds satisfaction in building a brick wall (66), just as God declared His creation good on each day in the first chapter of Genesis. Also, Tyurin tells a story to his "family," the work crew (88-93). If these

men were focused merely on survival, they would not care about working well or telling stories.

7. Where do we see the goodness of creation emerging despite the bleak world of the prison camp?

> At sunrise, we see how Alyoshka the Baptist "gazed at the sun and a smile spread from his eyes to his lips" (45). And near the end of the novel, we read, "The moon had risen very high. As far again and it would be at its highest. Sky white with a greenish tinge, stars bright but far between. Snow sparkling white, barracks walls also white. Camp lights might as well not be there" (170). At the end of the day, the moon outshines the artificial camp lights.

8. Is Shukhov a completely selfish character?

> Shukhov has learned how to survive in the "dog eat dog" world of prison (75). For example, he takes advantage of confusion to snag an extra two bowls of gruel at lunchtime (79-80). However, he also shows glimpses of generosity. He gives Senka the last part of his cigarette to finish (92) and presents Alyoshka the Baptist with a biscuit at the end of the day (181).

9. Why doesn't Shukhov want his family to send him care packages?

> Shukhov has learned from experience that when a prisoner receives a parcel of food, he has to give a portion of the food to everyone who handles it.

Therefore, he asks his family back home not to send him any packages, knowing that his wife and children would have to sacrifice so much to send it, yet much of it would be wasted. This is another example of Shukhov's considerate nature (138-39).

10. Why won't Shukhov eat the free-floating fish eyeballs in his soup?

This is a line he will not cross! In many cultures, eating eyeballs is taboo. James Serpell explains, "Eyes represent faces . . . and it's through the face that we learn to recognize and empathize with others. So it's not entirely surprising that we find eyeballs disconcerting."[40] Perhaps this represents one more way Shukhov retains his humanity; however, it is still not clear why he will eat them if they are in the fish's head, but not if they are free-floating (17-18).

11. Alyoshka the Baptist is clearly a Christian, but may Shukhov also be considered a Christian?

While Alyoshka appears throughout the novel as an ideal saint, Svetlana Kobets argues that Shukhov, though not professing his faith in words, shows many signs of being a "secret saint" or an "unconscious" believer following in the footsteps of Jesus Christ,

40. Nancy Shute, "Eating Eyeballs: Taboo or Tasty," The Salt (National Public Radio food blog), http://www.npr.org/sections/the-salt/2013/03/06/172902511/eating-eyeballs-taboo-or-tasty (accessed February 17, 2017).

at least according to Orthodox tradition.[41] Still, the Bible makes it clear that one must confess faith in Jesus Christ to be saved (Rom. 10:9). I would like to imagine that Shukhov eventually makes such a profession, just as Solzhenitsyn returned to Christianity during his time in prison.

12. What critiques of the Russian Orthodox Church are presented in the novel?

Shukhov's main critique is that the Church is corrupt, while Alyoshka's is that the Church has abandoned the faith. In the evening before lights out, Alyoshka and Shukhov are discussing spiritual matters including prayer. Shukhov begins to tell the story of the priest in his home parish of Polomnya: "Nobody was better off than the priest.... He was paying alimony to three women in three different towns and living with his fourth family. The local bishop was under his thumb, our priest greased his palm well" (176). Alyoshka replies, "Why are you telling me about this priest? The Orthodox Church has turned its back on the Gospels—*they* don't get put inside, or else they get off with five years because their faith is not firm" (177).

41. Svetlana Kobets, "The Subtext of Christian Asceticism in Aleksandr Solzhenitsyn's *One Day in the Life of Ivan Denisovich*," *The Slavic and East European Journal* 42.4 (Winter 1998): 672-73.

13. Are the critiques of the Russian Orthodox Church justified?

In the early years of the Revolution, the Communists attempted in their propaganda to accuse the clergy of immorality; however, there is little evidence of widespread corruption to support them.[42] As Timothy Ware observes in his work *The Orthodox Church*, the persecution of the Church under the Communist regime was unprecedented in Christian history; never before had the Church faced such "an aggressive and militant atheism."[43] Tens of thousands of bishops, clergy, and monks in the Orthodox Church were martyred in the 1920s and 1930s, while the Russian people themselves remained deeply religious.[44] Among the Orthodox believers, there was controversy over how much the surviving Church leaders should make concessions to the Soviet authorities, such as in 1943 when Metropolitan Sergius agreed to support Communist policies in return for restricted toleration to conduct worship services and train new priests.[45] So when Alyoshka says the church turned its back on the Gospels, his concern may be

42. Nathaniel Davis, *A Long Walk to Church: A Contemporary History of Russian Orthodoxy*, second edition (Boulder, CO: Westview Press, 2003), 9.

43. Timothy Ware, *The Orthodox Church*, second edition (Penguin, 1993), 145.

44. Ibid., 148.

45. Ware, *The Orthodox Church*, 156.

the church's cooperation with an atheist regime.[46] But we also must consider why Alyoshka is Baptist and not Russian Orthodox to begin with, as there are genuine doctrinal differences that would lead Alyoshka to choose the Evangelical tradition.[47]

14. Where do we see sacramental imagery in the novel?

We see sacramental imagery from the Orthodox Church reflected in several ways. First, there is the spoon which Shukhov treasures, having made it himself out of wire; in the Orthodox Church communion is served on a spoon (16). Also, there is the description of the old camp artist who painted numbers on prisoners' hats like "a priest anointing a man's forehead with holy oil" (30). Among the seven sacraments in the Orthodox Church are chrismation (confirmation) and unction (healing), both of which involve holy oil applied by a brush.

46. This cooperation was a concern that Solzhenitsyn would later express in his "Lenten Letter" of 1972. Ibid., 159.

47. For an exploration of some of these differences between Orthodoxy and Evangelicalism from a Reformed theological perspective, see Robert Letham, *Through Western Eyes: Eastern Orthodoxy: A Reformed Perspective* (Ross-shire, Great Britain: Mentor, 2007).

15. Where do we see examples of situational irony in the novel?

> The term *irony* refers to "the recognition of a reality different from appearance."[48] We find situational irony when things do not turn out as one would expect. For example, Shukhov as a prisoner was happy to have oatmeal gruel, but we learn that "Shukhov had fed any amount of oats to horses as a youngster and never thought that one day he'd be breaking his heart for a handful of the stuff" (77). Also, there is more freedom of speech within the hard-labor camp than in less harsh camps or among those not in camp: one prisoner refers to Stalin as "Old Man Whiskers," words he would never get away with on the outside (158). One of the overall ironies is that while the prisoners are not free, the "free" citizens of the Soviet Union are not free either. There was no freedom of speech. Those on the outside lived under a threat of being sent to prison themselves for any criticism they made of the regime. Solzhentisyn himself had to tone down some of the religious and political content in *Ivan Denisovich* to get it through the censors,[49] and his later work was censored entirely.

48. "Irony," in C. Hugh Holman and William Harmon, *A Handbook to Literature*, sixth edition (New York: Macmillan, 1992), 254-55.

49. Porter, 20-24. Porter gives some examples of what Solzhenitsyn deleted to get by the censors. The Willetts translation is based on the authorized canonical text that restores those passages.

16. Where do we see examples of verbal irony in the novel?

> Verbal irony reflects incongruity between the words and the actual meaning. For example, the escort commander gives the prisoners directions for marching out to the work site, which the narrator calls "the convict's daily 'prayer'" (39). Another way of achieving an ironic tone is through understatement, as exemplified in the closing lines: "The end of an unclouded day. Almost a happy one" (181). If a day living under such miserable conditions may be considered "almost a happy one," what would a bad day look like? The reader is left to conclude that there are even more terrible things that could be revealed.

17. What glimpses of life in the Soviet Union outside of the prison camps do we learn about?

> Shukhov gets letters from his wife twice a year. While people in his home village formerly had worked on the collective farm (the *kolkhoz*), now they are working in factories. The way men in his village had traditionally worked is no longer viable— they were carpenters, but now they are dyeing carpets. Shukhov's wife's dream is that Shukhov too will eventually dye carpets: "That way they could get out of the poverty she was struggling against, send their children to trade schools, and build themselves a new cottage in place of their old tumble-down place" (43). Shukhov hears from the other free workers he occasionally meets that "the straight and narrow was barred to ordinary people" (44)—instead, it is necessary to cheat in order to survive outside of prison.

18. Which Soviet films are referred to in the novel, and what is their significance?

> One of the prisoners, Tsezar Markovich, is a filmmaker who eagerly engages others in discussions of cinema. In a conversation with a prisoner referred to as "Kh-123,"[50] Tsezar praises *Ivan the Terrible*, a 1944 film directed by Sergei Eisenstein and commissioned by Joseph Stalin, who fancied himself to be a modern-day Ivan the Terrible. The other prisoner, who is doing a twenty-year sentence, is not impressed: "So much art in it that it ceases to be art.... And the political motive behind it is utterly loathsome—an attempt to justify a tyrannical individual" (85). Solzhenitsyn, who clearly valued truth in art, as he explains in the "Nobel Lecture," would sympathize with Kh-123's position. At another point, Tsezar discusses with Captain Buynovsky an earlier silent film by Eisenstein, *Battleship Potemkin* (1925), which is about the Revolution of 1905, a prelude to 1917's Revolution. These cultural references show that artistic works were still being produced in the Soviet Union; however, the works had to get through censors and thus, if they were not outright propaganda, they must not contain anything objectionable to the Soviet authorities.

19. The camp includes prisoners of other national origins besides Russians. How are they portrayed?

> As the narrator observes, "People said national-ity didn't mean anything, that there were good

50. Porter, 97.

and bad in every nation. Shukhov had seen lots of Estonians, and never came across a bad one" (51). The Lithuanians along with the Estonians are described as "meek" (23). Kildigs, a Latvian, is a good worker and was prosperous back in Latvia like everyone else there (109). Other national groups who are portrayed positively include the Western Ukrainians, who are described as still being polite (25), and even cross themselves before meals (15). Other groups mentioned less favorably include the Hungarians, Romanians, and Moldovans (123).

20. How does *Ivan Denisovich* compare to other great works of Russian Literature?

> In a 1967 interview, Solzhenitsyn says, "I was brought up with Russian literature and only circumstances prevented me from pursuing more extensive studies.... Russian literature has always been sensitive to suffering."[51] Two obvious connections are to Fyodor Dostoevsky, who was imprisoned in Siberia in the 1850s and wrote a chronicle of that experience called *The House of the Dead*. Like Dostoevsky, Solzhenitsyn renewed his Christian faith while in prison. Solzhenitsyn read Leo Tolstoy's novel *War and Peace* as a ten-year-old. Robert Porter shows that though it is compact in scope, *Ivan Denisovich* shares many characteristics of Tolstoy's epic through its subject matter and its character creation.[52]

51. Quoted in *Solzhenitsyn: A Documentary Record*, 15.

52. Porter, 67-81.

21. How does *Ivan Denisovich* measure up to the purpose of literature as articulated in the author's "Nobel Lecture"?

> Solzhenitsyn said in the "Nobel Lecture" that literature "recreates—lifelike—the experience of other men, so that we can assimilate it as our own."[53] By focusing on just one day in one man's life, we are able to grasp a phenomenon that—multiplied by millions and spanning thousands of days—would be incomprehensible to us. Through the suffering of Shukhov and his fellow prisoners, we sense the injustice of a regime that lived on lies and put men in prison on trumped-up charges. Literature thus offers us a chance to learn from humanity's mistakes in the past, so that we might not make the same ones again. We should oppose regimes that operate based on lies and counterfeit utopian visions of salvation. We should also be careful that in our opposition to such regimes, we do not ourselves become oppressors, for, as Solzhenitsyn wrote in *The Gulag Archipelago*, "the line separating good and evil passes not through states, nor between classes, nor between political parties either—but right through every human heart—and through all human hearts."[54]

53. Solzhenitsyn, "Nobel Lecture," 519.
54. Solzhenitsyn, "The Ascent" from *The Gulag Archipelago*, in *The Solzhenitsyn Reader*, 265.

FURTHER DISCUSSION
AND REVIEW

Master what you have read by reviewing and integrating the different elements of this classic.

SETTING AND CHARACTERS

1. What difference does it make that the novel is set in winter instead of summer?

2. Compare how different characters respond to life in the prison camp.

- Which characters still maintain human dignity? How do they show they are still human and not animals?

- Which characters have adapted well to life in prison?

- Which characters are not likely to survive?

PLOT

1. This novel has no chapter breaks. Is there a clear beginning, middle, and end?

2. If you had to divide the novel into sections, where would you put breaks?

CONFLICT

1. Does Ivan have any internal conflicts?

2. What are some conflicts among prisoners?

3. What are the conflicts between the prisoners and the guards?

4. What conflicts are there between the man-made environment and the natural world?

5. What conflicts does the novel describe as going on in the world outside the camp?

THEME STATEMENTS

Here are some big ideas presented in the novel. For each one, explore how the novel illustrates these ideas with several examples. Then evaluate whether this idea is true according to the standard of Scripture.

1. Despite every attempt of an oppressive regime to suppress them, truth, goodness, and beauty still emerge.

2. No amount of inhumane treatment can keep the image of God from showing forth in man.

3. Suffering, when understood in the proper light, can be a great benefit to the Christian.

Now compose your own theme statement from the novel. Evaluate whether it is true according to Scripture. Here are some key words that may serve as a starting point: *truth, goodness, and beauty; freedom and captivity; nature and man-made surroundings; inhumanity and the image of God; prayer and action; death and survival; body and soul; justice and injustice; coldness and warmth; hunger and satisfaction.*

FOR FURTHER EXPLORATION/CREATIVE WRITING

1. Imagine Shukhov and Alyoshka both survive their sentences and meet as old men in the year 1991, as the Soviet Union is collapsing. Construct a dialogue between them.

2. How might you be able to connect personally with Shukhov's experience?[55]

- Have you ever been cold? Write a poem or story about being cold. Extra challenge: do not use the words *cold* or *frozen*, or any form of those words!

- Write "A Day in the Life of [your name]", starting with your first waking moments and including as much detail as possible on a particular but typical day.

55. The following prompts are inspired by similar activities suggested in James R. Cope and Wendy Patrick Cope, "A Teacher's Guide to the Signet Classic Edition of Alexander Solzhenitsyn's *One Day in the Life of Ivan Denisovich*" (New York: Penguin, 1993), 6. The Copes have produced a guide with many helpful features, available online at http://www.penguin.com/static/pdf/teachersguides/denisovich.pdf (accessed February 17, 2017).

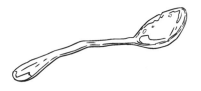

A NOTE FROM THE PUBLISHER:
TAKING THE CLASSICS QUIZ

Once you have finished the worldview guide, you can prepare for the end-of-book test. Each test will consist of a short-answer section on the book itself and the author, a short-answer section on plot and the narrative, and a long-answer essay section on worldview, conflict, and themes.

Each quiz, along with other helps, can be downloaded for free at www.canonpress.com/ClassicsQuizzes. If you have any questions about the quiz or its answers or the Worldview Guides in general, you can contact Canon Press at service@canonpress.com or 208.892.8074.

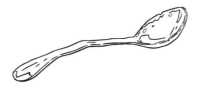

ABOUT THE AUTHOR

Stephen Rippon has been a teacher at Tall Oaks Classical School in Delaware for more than a decade, and before that he taught at the U.S. Air Force Academy. He has a Master of Divinity from Westminster Theological Seminary. His work has been published in *Classis*, The *Dictionary of Literary Influences*, and *War, Literature & the Arts*. He and his wife, Jennifer, have three children.

Made in the USA
Middletown, DE
14 May 2019